ESSENTIAL GUIDE TO
DRAWING

Portraits

ESSENTIAL GUIDE TO
DRAWING
Portraits

A PRACTICAL AND INSPIRATIONAL WORKBOOK

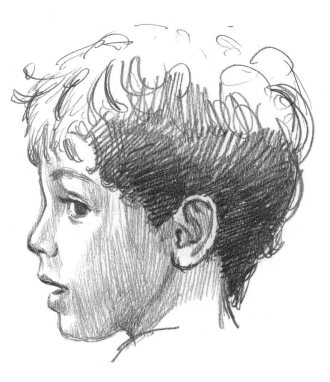

BARRINGTON BARBER

ARCTURUS

ARCTURUS

This edition published in 2012 by Arcturus Publishing Limited
26/27 Bickels Yard, 151–153 Bermondsey Street,
London SE1 3HA

ISBN: 978-1-84858-807-3
AD002351EN

Printed in Singapore

CONTENTS

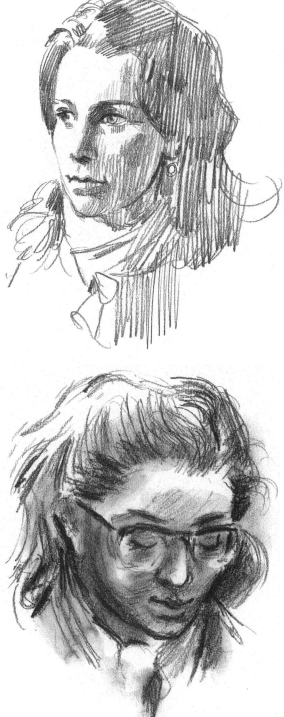

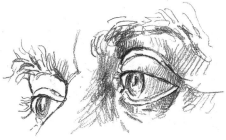

//// Introduction

The human face is often the most attractive subject for an artist. In a way, producing a good portrait of another human being proves to yourself how well you are progressing; it is the hardest area in which your skills will be tested, because everyone can see at once whether you have attained a resemblance to the individual or not.

There have been many brilliant portrait painters and therefore no dearth of examples to look at. Friends and relatives will be quite keen to sit for their portraits because it is a kind of compliment – to think that their face is worth drawing by the artist. However, you will be taken to task if they think you have missed their likeness. Don't worry though – as any good artist knows, the likeness of an individual is by no means the whole story, or why are we so impressed by the old masters' paintings of people that we have never seen? One thing you must appreciate when attempting a portrait is that the whole head is the key to getting a good result, a fact that many beginners fail to realize. Don't forget to refer to the proportions of the head (pages 8–9), otherwise the final result might look like a face lacking the foundation of a properly constructed skull.

Any medium is valid for drawing portraits and I have shown a range of possibilities here and later in the book. The suitability of what you choose depends on what you are trying to achieve. You probably don't need to buy all the items listed below, and it is wise to experiment gradually. Start with the range of pencils suggested, and when you feel you would like to try something different, do so. For paper, I suggest starting with a medium-weight cartridge paper.

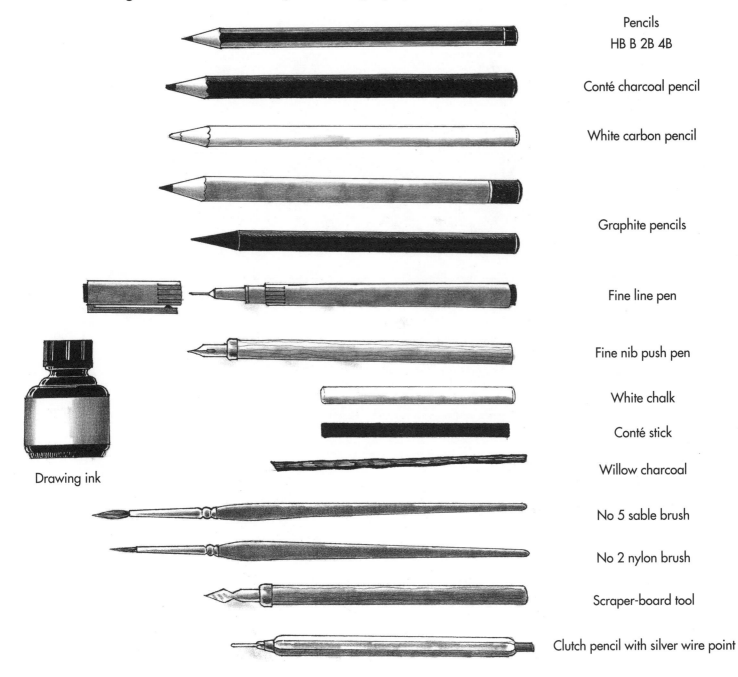

Pencils
HB B 2B 4B

Conté charcoal pencil

White carbon pencil

Graphite pencils

Fine line pen

Fine nib push pen

White chalk

Conté stick

Willow charcoal

Drawing ink

No 5 sable brush

No 2 nylon brush

Scraper-board tool

Clutch pencil with silver wire point

Proportions of the Head

Here we look at some of the classic rules of drawing portraits: the proportions of the human head. These are useful guidelines for any artist, and learning them will help to inform your drawings and make them more accurate.

Profile view

This view of the head can be seen proportionately as a square which encompasses the whole head. When this square is divided across the diagonal, it can be seen immediately that the mass of the hair area is in the top part of the diagonal and takes up almost all the space, except for the ears.

When the square is divided in half horizontally it is also clear that the eyes are halfway down the length of the head. Where the horizontal halfway line meets the diagonal halfway line is the centre of the square. The ears appear to be at this centre point, but just behind the vertical centre line.

A line level with the eyebrow also marks the top edge of the ear. The bottom edge of the ear is level with the end of the nose, which is

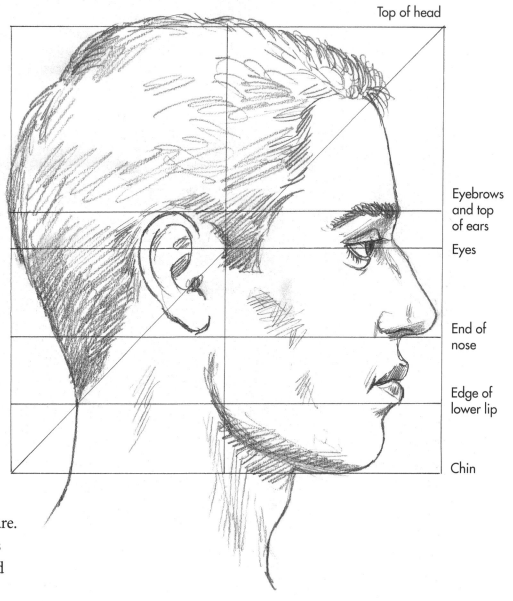

Top of head

Eyebrows and top of ears

Eyes

End of nose

Edge of lower lip

Chin

halfway between the eyebrow and the chin. The bottom edge of the lower lip is about halfway between the end of the nose and the chin.

While these measurements aren't exact, they are fairly accurate and will hold good for most people's heads.

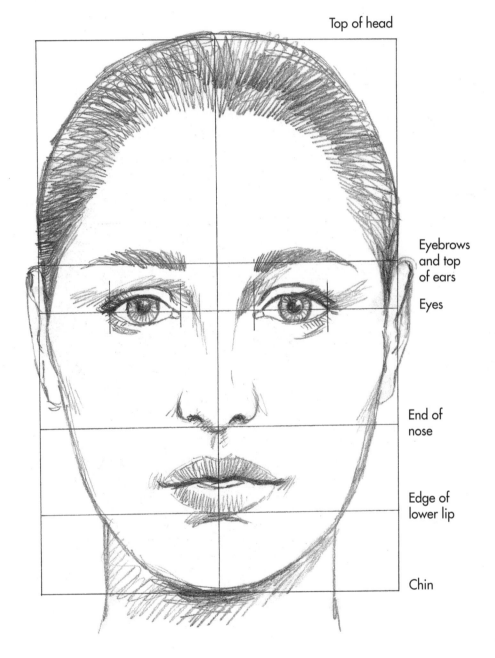

Top of head

Eyebrows and top of ears

Eyes

End of nose

Edge of lower lip

Chin

Front view

From the front, as long as the head isn't tilted, it is about one and a half times as long as it is wide. The widest part is just above the ears.

As in the side view, the eyes are halfway down the length of the head and the end of the nose is halfway between the eyebrows and the chin; the bottom edge of the lip is about halfway between the end of the nose and the chin.

The space between the eyes is the same as the length of the eye. The width of the mouth is such that the corners appear to be the same distance apart as the pupils of the eyes, when looking straight ahead.

These are very simple measurements and might not be quite accurate on some heads, but as a rule you can rely on them – artists have been doing so for many centuries.

//// Angles of the Head

Before you embark on a portrait, it is a good idea to sketch the head from different angles first to get a feel for its overall shape, and to decide how you want to draw your sitter. In most cases you'll need to show the face clearly so that your sitter can be easily recognized, but there are several variations on just a full face.

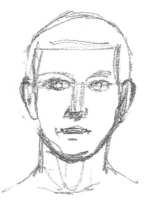

A full-face view with the eyes level is a common approach, but you might want to show some of the shape of the nose, which can't be seen so easily from directly in front.

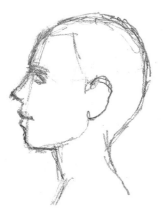

The profile view is very good for the nose and the shape of the head, but of course from this angle you can't see both eyes. This tends not to appeal to the viewer.

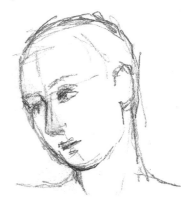

A three-quarters view with the head tilted downwards can be effective, but often gives the impression of sadness.

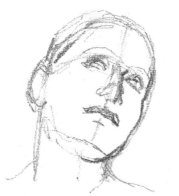

A three-quarters view with the head tilted backwards is interesting to draw, but people may not be able to recognize themselves from that angle.

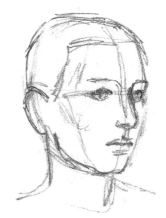

A three-quarters view with the head held level is the one used most often by portrait artists, because everyone can recognize the face and the shape of the nose can also be seen. This is why it is so popular.

These drawings show other versions of heads in different positions, but this time with the hair and features put in more naturally. Try to sketch as many different versions of heads as you can, because it will improve your ability to draw portraits in more depth. Again do as many of them from life as you can, resorting to photographs if need be. Notice how the shadows on the faces give an extra dimension, not only to the form but also to the expressions.

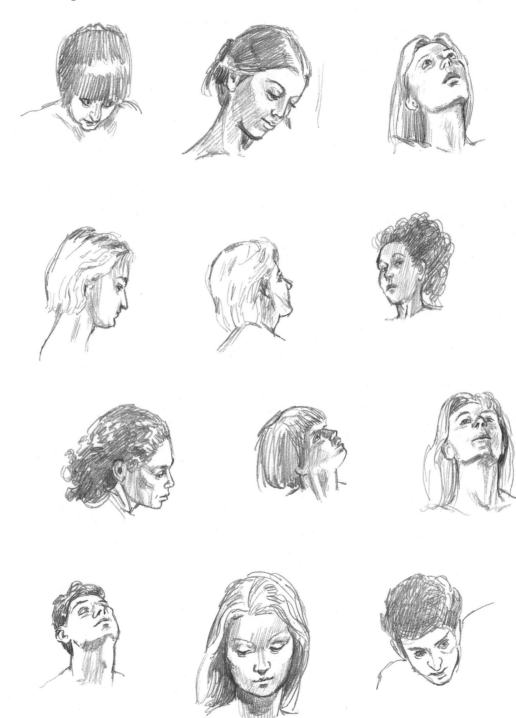

When you draw a portrait, measuring the head as accurately as you can before you start will help you to reach a successful result; you'll have the proportions clear in your mind before you begin making marks.

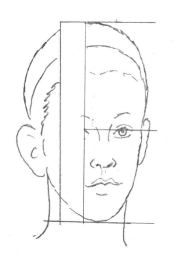

Using a ruler, first measure the length of the head and establish the position of the eyes.

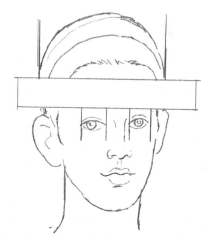

Measure the width at its widest point, which is just above the top of the ears, then measure the length of the eyes and the space between. Also measure the distance from the edge of the head to the inner corner of the eye, as you can see it.

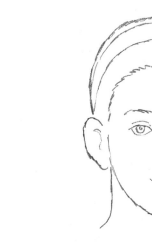

Next mark the distance from the top of the head to the hairline; from the hairline to the eyebrows; from the eyebrows to the end of the nose; and from the end of the nose to the bottom of the chin. As you go along, mark all these on your paper.

Then place your ruler side-on down the centre of the face so that you can see what differences there are between the two sides of the face – nobody has one that is exactly symmetrical. This helps to get the character of the face more effectively.

1.

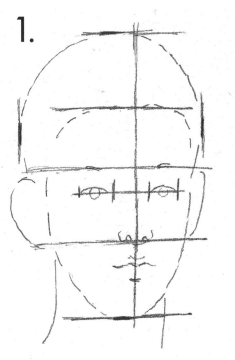

2.

3.

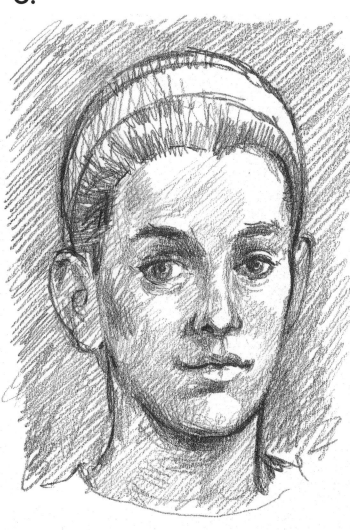

The drawing at the top left (1) contains all the marks necessary to make a fairly accurate portrait, and it is now just a question of joining them up to make sense of them; you can go ahead with some conviction that you are getting the proportions correct. Put in all the tonal values when the shapes look right (steps 2 and 3).

Portrait Hints

Here are some practices that I have found useful when drawing portraits. They should help you to get a good likeness of your subject, and to improve your drawing skills.

Take a photograph of the model in the pose you've chosen, so you can refer to it to correct the proportions in your drawing if necessary. Take your photograph from exactly the same viewpoint you will use when you're drawing.

Make a print or photocopy of your photograph as close to the size of your drawing as possible, then trace it so that you have a simple outline drawing to give you the right proportions of the head. Once you have the tracing, copy it on to your paper by placing the paper over the tracing on a window or a lightbox.

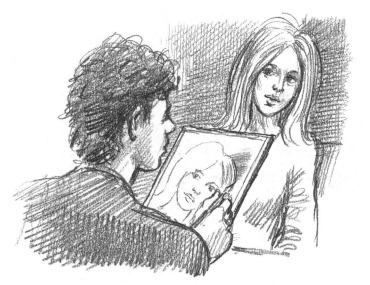

Now you have the correct proportions already mapped out, and – sitting in front of your model – you can continue to draw and get a much better likeness. You may think this is cheating – you're right, but all art is cheating, really, and artists have always used many such methods to improve their drawings.

It is good practice to copy other artists' work in order to increase your technical skills – a traditional method of learning to draw well. If you want to know how Leonardo drew, for example, try copying one of his drawings from a print or a book and see how close you can get to reproducing it. Draw with your print close to your own drawing, because this increases your chances of being accurate.

Another time-honoured method to improve drawing skills is to place your print upside down next to your paper and carefully copy it in that position. What this helps you to do is to see that you are just drawing shapes rather than faces and once you begin to see just shapes and lines you'll find it easier to analyse what you are drawing.

Drawing a Head and Face

This exercise is one for which you will need a model. If someone you know will sit for you for an hour you can draw their face, but if this is difficult, simply position yourself in front of a good-sized mirror and draw your own.

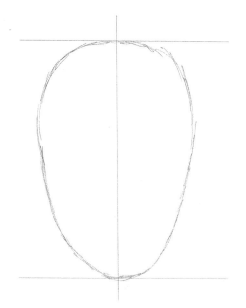

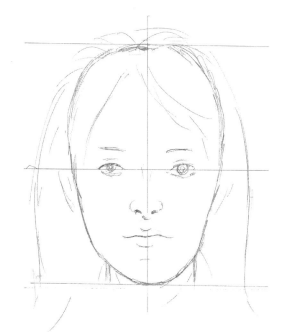

1. To start with you need to draw a straight-on, full-face view, so that you can see the proportions of the head and features clearly. Make a mark at the top of the page to indicate where the top of the head is going to be, and another where the point of the chin will go. Don't make the distance between these two points bigger than the size of the head, although it doesn't matter if it is a bit smaller. Now draw a line straight down to join the top mark to the bottom. This indicates the centre of the head vertically. All the shapes you are going to draw should be evenly balanced either side of this line. Looking carefully at the shape of the head in front of you, have a go at drawing the oval shape of the whole head, not just the face. You'd be surprised how many beginners draw the head as though there is nothing much above the hairline.

2. Draw a horizontal line halfway down the head to show the level of the eyes. Mark in the position and shape of the eyes on this line. The distance between them is the same as the length of the eye from corner to corner.

Then mark in the end of the nose, about halfway between the eyes and the point of the chin. Draw just the nostrils and the bottom edge of the nose. Next draw the line of the mouth, which is slightly nearer the nose than the chin – it is usually positioned at one-fifth of the whole head length from the bottom of the chin. Draw the shape between the lips, then, more lightly, put in the shape of the upper lip below the nose.

Mark in the hair, the position of the ears, and the eyebrows. The tops of the ears and the eyebrows are at about the same level.

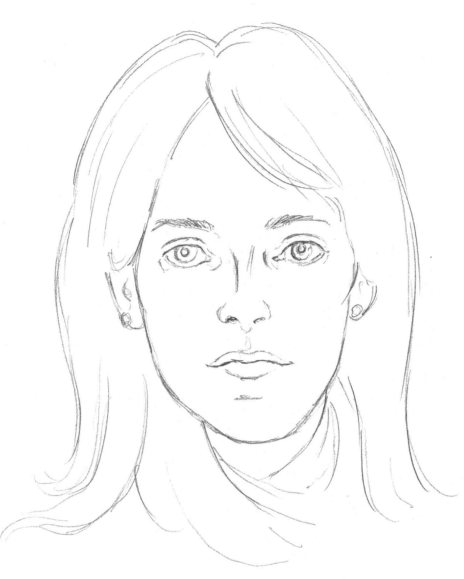

3. The next stage is to draw all the features and the hair, correcting any mistakes as you go. Look at the thickness of the eyebrows and note that the shape of the inner corner of the eye is different to that of the outer. If the eyes are looking straight at you, the iris is slightly hidden by the upper eyelid and usually touches the lower one.

The most important areas of the nose are the under part and the shape of the nostrils. There are usually marks that you can draw lightly to indicate the area where the nose is closest to the eyes and there may be a strong shadow showing the bonier part of the nose; mark this in lightly.

The mouth is a bit easier, but remember that the strongest marks should be reserved for the line where the lips meet; if you make the edges of the lip colour too strong it will have the effect of flattening the lips. There is usually a strong fold under the lower lip which can be more defining of the mouth than the edge of the colour.

The outline of the jaw and cheekbones is important to show the characteristics of the face, so take your time to get this right.

The hair is also important, especially where it defines the shape of the skull underneath.

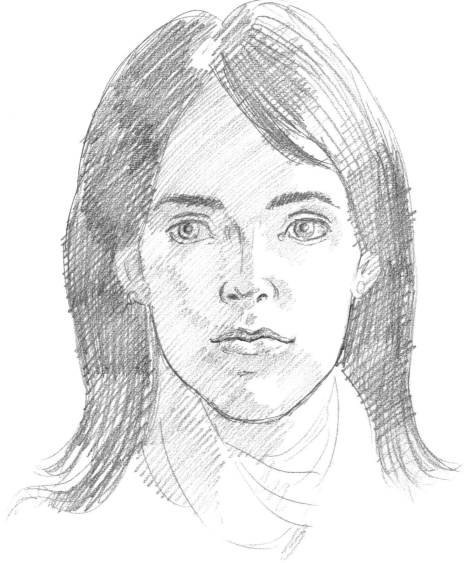

4. Now you can start to mark in the shading on the face and hair, putting it all in at the same strength. There will usually be light coming from one side, and in my example the left side of the face is in some shadow and the right side is in more light. This stage is where the projecting features such as the nose, eyebrows and mouth start to show their form.

Shade the hair in the same way, but take the marks in the direction that the hair grows. If the hair is dark, put another layer of tone everywhere except where the light shines strongly on it.

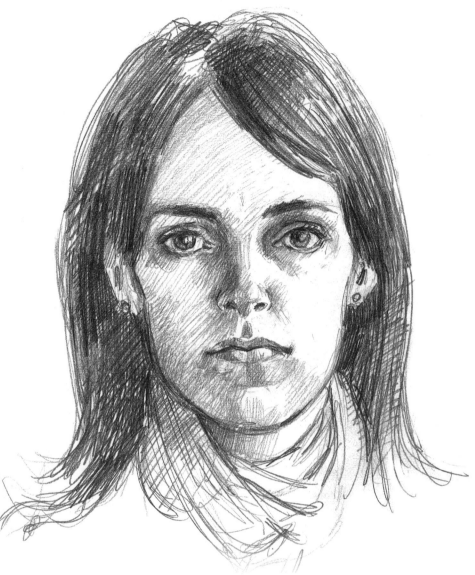

5. In the last stage, draw in the very darkest tones and the variety of tones over the whole head. You may have to darken the hair quite a bit, but remember that only the deepest shadows should be black.

Mark in the edges of the eyelids carefully. The edge of the upper lid is much darker than the lower, partly because it is facing downwards and partly because the eyelashes cast a shadow. The pupil of the eye is dark, but usually you can see a bright speck which reflects the light in the room, which gives the eye its sparkle. Note the shadow around the eye near to the nose.

The shading around the nose and the mouth should be done very carefully – if you make it too dark the result will look a bit cartoonish. Try to let the tones melt into each other so that there are no sudden changes. The shading on the sides of the jawline are often darker than on the point of the jaw because the light is reflected back up under the chin. Keep stopping to look at the whole picture to see if you are getting the balance of tone right. Don't be afraid of erasing over and over again to get the right effect – the result may end up a bit messy, but you will have learnt a valuable lesson about drawing form.

Children

Children's heads don't match the proportions of an adult head. The greatest difference is the size of the cranium in relation to the lower jaw, but also the eyes are more widely spaced than in an adult and the cheeks are usually rounder. All the features fit into a much smaller space, and of course there are hardly any lines on the face.

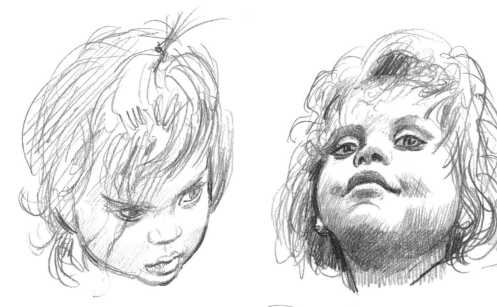

These drawings of a little girl of four or five years of age, viewed from above and below, show the soft rounded cheeks and small snub nose which are fairly typical of the age group.

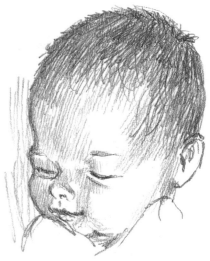

The little boy is a bit older but doesn't have a fully grown jaw yet. His eyes and ears look much larger in relation to his nose and mouth than they would in an adult.

The little baby is an even more extreme shape, having a much larger cranium than face, with all her features being close together in the lower part of her head.

Ageing

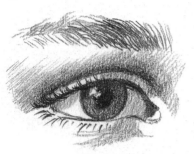

Now let's look at the effect of age on the eye. This is quite important, because it is the eyes that mainly give us the clues as to how old someone might be. The first eye is of a little boy of six and looks as big and lustrous as any young woman's might. There are hardly any lines around the eye.

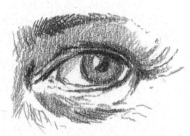

Next we have someone of middle age. Although the eye is still quite lustrous there are lines around the eye socket that give you some idea of the age.

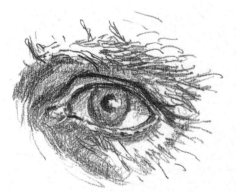

This is the eye of an elderly person, with all the multifarious lines etched into the skin and the straggly eyebrows.

Finally, I want to show you a drawing of a young woman at her peak and one of an old man – my youngest daughter and myself. See the difference in the quality of the hair, on the one soft and shiny, the other white and sparse. Then look at the surface of the skin. Although my daughter is grinning widely she has very few lines on her face and her eyes are very clear. My own skin is furrowed with lines of all kinds, especially around the eyes and on the forehead. The cheeks look more hollow and the mouth is defined only by its edge. I appear to be staring intently; that's because I am of course drawing myself in a mirror.

//// Facial Details

Having had some practice at portrait drawing, your next exercise is to look at the face in some detail to familiarize yourself with its constituent parts.

Eyes

The most significant part of the face that we recognize are the eyes, so we will start there. You can begin by drawing only one eye, but it is probably a good idea to draw both together so that the relationship of the two eyes to each other is observed.

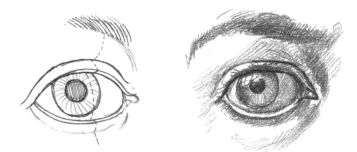

Now try drawing one eye, taking note of every detail of its shape and construction. I have drawn a diagram of the eye as well to emphasize its form. Note that the inner corner has the tear duct hollow, while the outer corner is simpler. The thickness of the eyelids can be seen on both the upper and lower lid, and they curve over the eyeball. The pupil will of course enlarge or diminish according to how much light is shining on the eye.

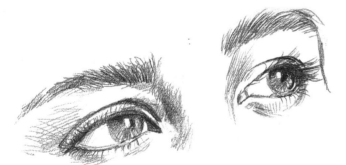

This drawing is of the eyes of a young woman who is looking to one side. Notice how the inner shape of the corner of the eye is different to that of the outer corner and how the eyes are set slightly around the curve of the head. Draw the eyebrows as well so that the space between the eyes can be judged more easily. This girl's eyes are looking up towards the light, so they are not open wide – the iris (the coloured part of the eye) is covered slightly by the upper lid and is touching, if not slightly under, the lower lid.

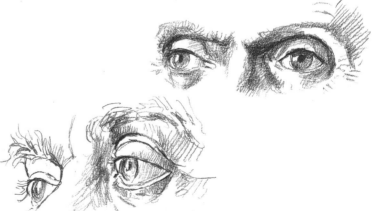

Now go back to drawing a pair of eyes, only this time try someone of a different age. I have shown the eyes of two older men, so the shape and texture of the skin around the eyes are a bit different. Notice the wrinkles and pouches around the eyes, and the difference in the eyebrows.

Mouths

Mouths are the next most recognizable part of the human face, except in the case of someone with a really dramatic nose. Draw mouths both shut and slightly open to understand the formation of the lips; the lower lip is often thicker than the upper one, but this is not invariably the case.

Don't forget to draw the mouth from the side as well, and notice whether the lower lip protrudes less or more than the upper lip.

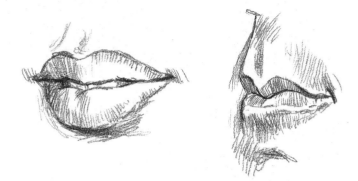

The typical Cupid's bow shape of the upper lip is often more sharply defined than the lower lip. When you draw the mouth, don't draw the colour of the lips, just their form, otherwise it will look as though all your people have strong lipstick on. The diagram on the left shows how the curves of the lips work as an overall shape.

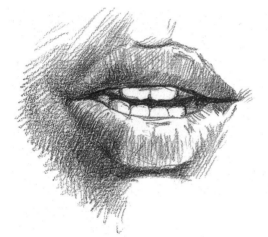

This is more obvious when you draw the mouth open.

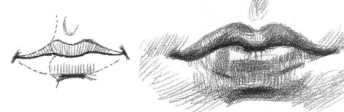

The strongest line of the mouth is where the lips part, not around their outer edge.

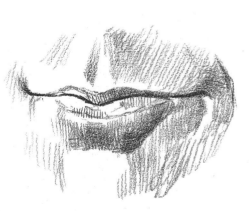

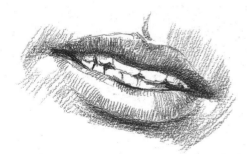

When the mouth is slightly open you will be able to see some teeth. Leave plenty of untouched paper here or they will tend to look very grubby.

Noses

There is a lot of variation in noses, and they often form a very characterful part of the face. They are not at all hard to draw in profile, but quite tricky full-face.

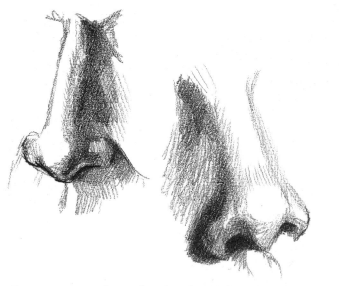

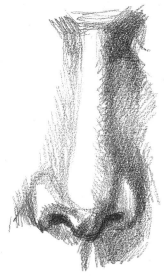

It is easiest to describe the shape from the front when there is a strong light coming from one side to cast a shadow.

If the light is more even, be careful not to overemphasize the tonal values on the nose.

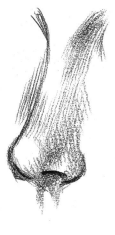
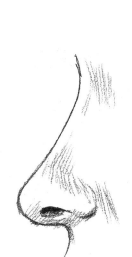
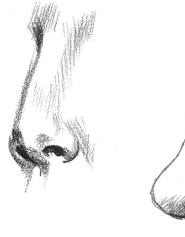
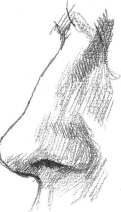

Most noses come in three or four types: the snub or retroussé nose, the straight nose, the strong, curved nose or the broken nose. The straight nose is probably the most difficult to draw because of the lack of bumps or indentations. Most beginners tend to make their subject's nose too long or too short, so observe it carefully in relation to the rest of the face.

Ears

Ears are often neglected in a portrait because long hair is partially hiding them or because we rarely look at them.

Here are a few examples of different ears and you should have a go at several, because they do have various shapes. The construction is basically the same, but the details differ. Draw some ears from the side and then from the front as well to get some idea of how they look.

Exploring Tone

To tackle tone on a subject as complicated as a portrait, you need to observe where the light is coming from and be consistent with where you place your shadows – just as you would do with any other object.

1. The first stage is an outline drawing of a head – at this stage the only requirement is for a clear and correctly proportioned shape that includes the position of the features and the area of the hair.

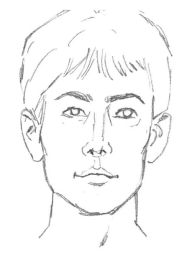

2. In the second drawing the shapes of the features are more clearly described and you can gain some idea of the solidity of the head without yet seeing any of the form defined by tone.

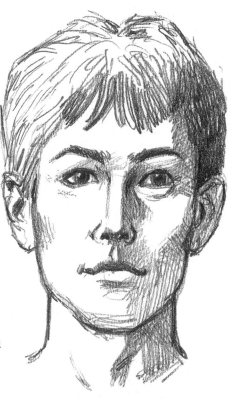

3. The next drawing shows the head with the first main areas of tone put on uniformly and quite strongly. Of course you might not want to use tone quite so boldly as you may be aiming for more subtle areas of shade, but this gets the idea across.

4. In the final stage you can go full tilt at the tonal area and show some parts darker to give the most convincing feel of dimension and depth. At this stage you might decide to soften some edges of tone as well.

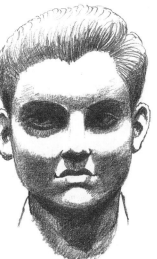

1. Lit from directly above, producing dark shadows around the eyes and under the nose and chin.

No matter what you are drawing, the light source is important. Here we look at the effect of different lighting on the same face. Lighting teaches a lot about form, so don't be shy of experimenting with it.

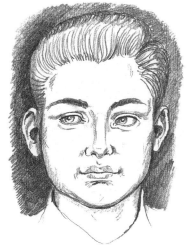

2. Lit from the front, flattening the shape, resulting in loss of depth but showing increased definition of the features.

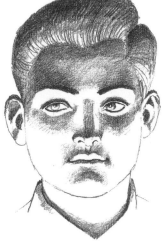

3. Lit from beneath. Everything is reversed and it is difficult to believe this is the same boy as in the first picture. The shadows are now under the eyes but not under the brow, and on top of the nose instead of under it. This lighting technique gives the drawing a decidedly eerie feel.

4. Lit directly from the side. Here, half of the face is in shadow and the other half is strongly lit.

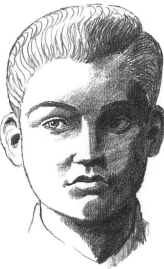

5. Lit from above and to one side. The lighting evident here is fairly standard. The shadows created define the face in a fairly recognizable way.

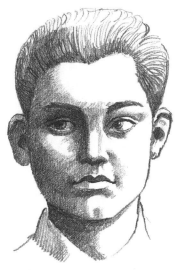

As this series of images shows, directional lighting can make an immense difference to a face. Experiment for yourself, using a small lamp or candles. Place your model at various angles and distances from a light source and note the difference this makes. When you find an effect that interests you, draw it.

A Full-figure Portrait

This exercise will seem like a reward for all your hard work so far – drawing a complete portrait of someone who is prepared to pose for you for a while. As my model I took my six-year-old grandson. He is not easy to keep in one position, so I put him in front of the television and he sat for a little longer than usual. That in itself is a lesson – make your models comfortable and happy and you will get more time to draw them!

1. At first you will need to draw the main shape of the figure. Keep it very simple to start with and use your eraser, correcting as much as you can at this stage – it saves time later on.

2. The next stage is to put in all the shadows that seem relevant, again keeping everything simple – at this stage, it is the face that needs to become recognizable.

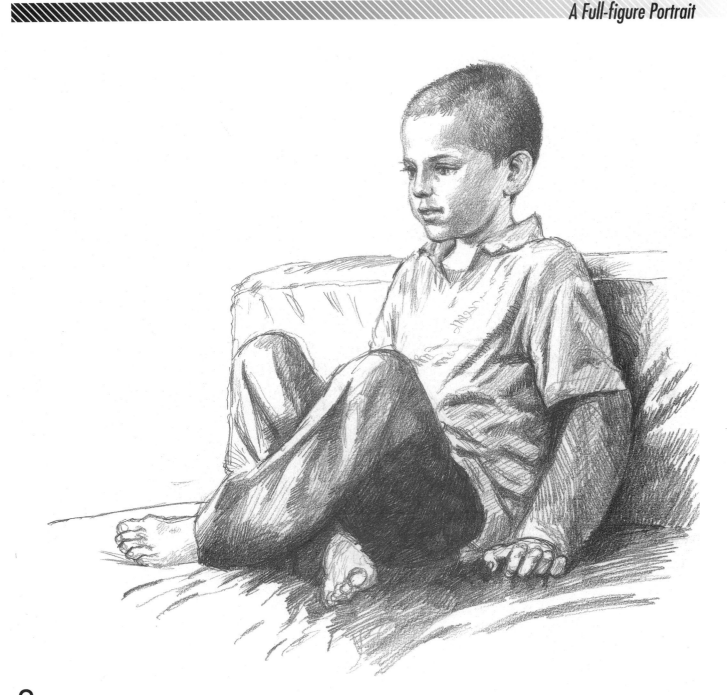

3. Once you are sure everything is the right shape and in the correct proportion, begin to work into the picture to make it come to life. Take great care over the head, because this is where the picture becomes a portrait of a particular individual rather than of just anyone. This is not so difficult as it sounds because we all have this marvellous ability to recognize human faces, so you will automatically draw the features correctly if you really pay attention. Build up the tones in such a way as to stress the softness or hardness of the form.

Different Approaches

While a portrait should resemble the sitter in some way, that doesn't mean it must be time-consuming and full of detail. Here we consider several examples of portraits that approach the subject in different ways and reveal the effects of various media.

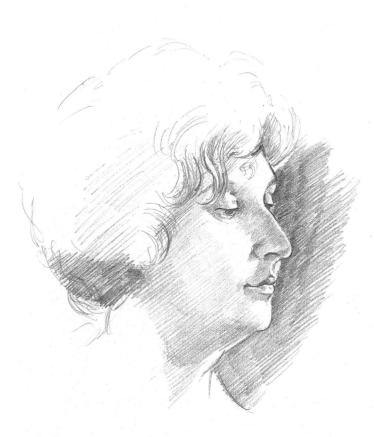 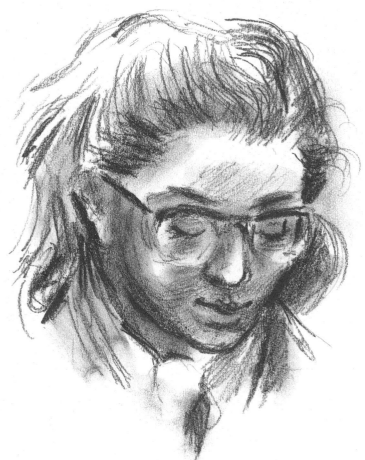

This subject was unable to sit for long, so I drew the main features of the face and just indicated the rest of the head using quick strokes of my pencil. Notice how the background tone that shows up the profile clearly is just as important as the face itself.

In this charcoal drawing the model is looking downwards, and the significant thing here is the spectacles. These are often omitted from portraits as they can act as a sort of disguise to the face. Of course, if your model always wears spectacles, removing them will result in a portrait that looks less like the person that everyone is familiar with. Notice how much shadow there is on the lower half of the face, because the model's head is inclined.

This pencil sketch is based on a head and shoulders portrait by Ingres (1780–1867). Ingres was renowned for his very accurate portraits, and most fashionable Parisians of his day wanted to sit for him. He was reputed to use optical devices to achieve this accuracy; these days we would use a camera.

This head and shoulders portrait is a profile view of a young girl drawing in one of my classes. I took the chance to draw her in brush and wash while she concentrated on her own work.

Master Examples

Over the next few pages we look at how three artists have approached portraits. You'll see the impact of their respective styles and interpretations.

The English illustrator and painter Henry Carr (1894–1970) was an excellent draughtsman, as these portraits show. He produced some of the most attractive portraits of his time because of his ability to adapt his medium and style to the qualities of the person he was drawing. The subtlety of the marks he makes to arrive at his final drawing varies, but the result is always sensitive and expressive. A noted teacher, his book on portraiture is well worth studying.

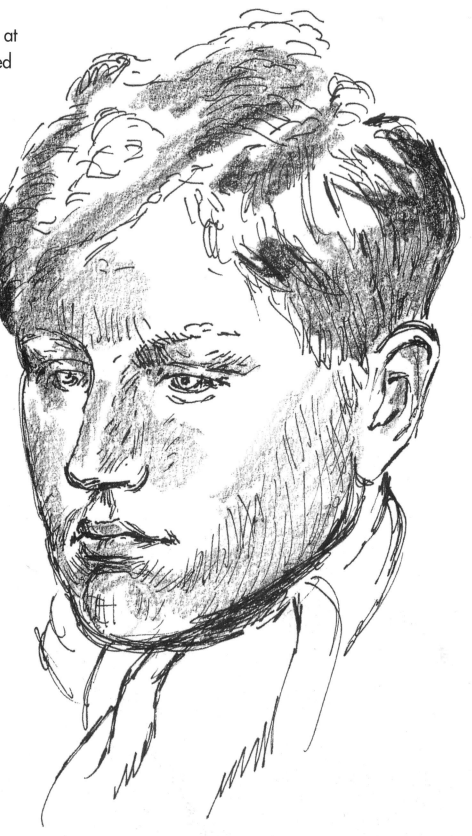

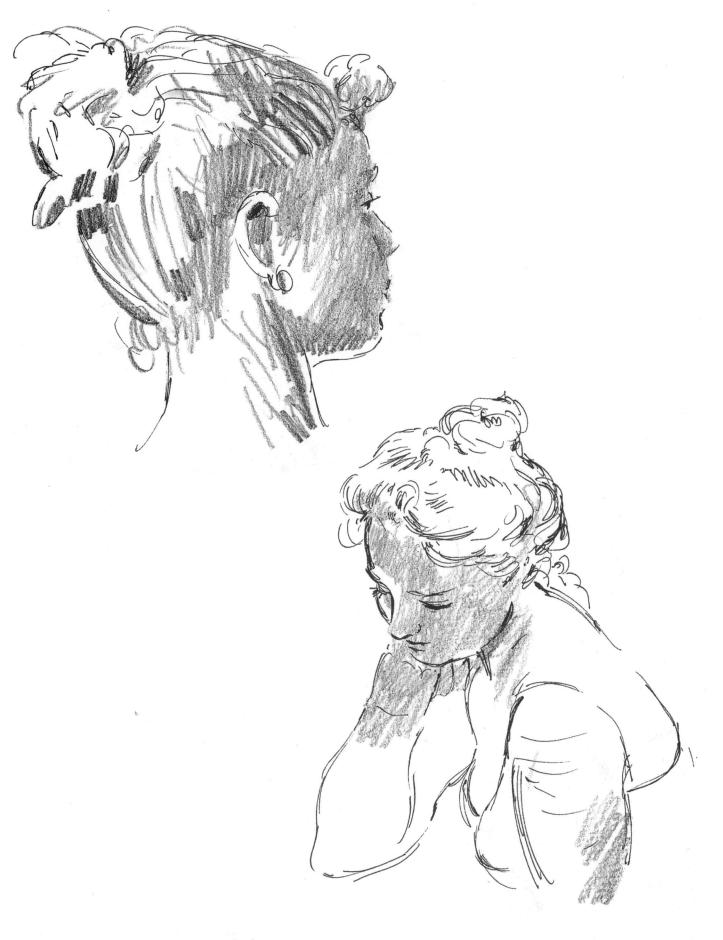

Here are two drawings after David Hockney's portraits, in different modes of expression. The first, of the cross-dressing performer Divine, is a full-figure picture, and gets across the amusing and dramatic nature of the character. The portrait looks like a performance, which is apt.

In contrast, the one of his mother is close up and rather tender in its regard of the sitter. Although he doesn't miss out any facets of the time-worn face, he infuses it with a gentler, wistful look. This goes some way to showing why he is considered such an accomplished artist.

Next, we have a couple of examples after the brilliant painter Lucian Freud (1922 –2011). The first one, of the prominent lawyer Lord Goodman, is a pen drawing with multiple etched lines defining the form of the head. As the sitter has a very distinctive head and features, the artist is not afraid to pile on the effect of lines and bulges in the form. One of the reasons Freud is so cherished as a portrait painter is that he certainly didn't hold back from showing every blemish on the surface of his models.

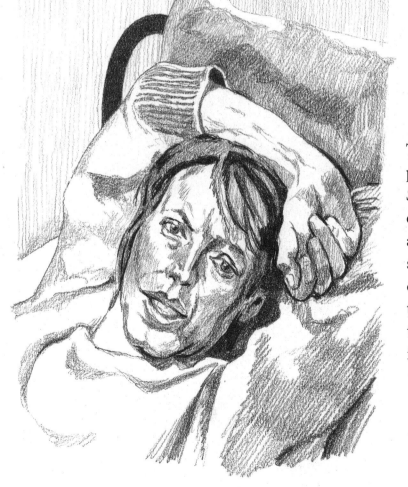

The second is taken from the painting *Woman in a Grey Sweater*. The main characteristics of the form are shown simply and powerfully, giving a strong sense of the dimensional qualities of the head. Notice the way the arm curled around the head helps to give added informal framing to the face.

////// Composition: Putting the Subject in the Frame

When about to draw a portrait, the format of the picture is a major consideration. This is usually the normal portrait shape, taller than its width. But of course this might not always be the case, and you should follow your own ideas. In the examples I have chosen, I've stuck to the upright format in order to simplify the explanation. The idea of these pictures is to give some thought to the way that you use the format to determine the composition. You might choose to draw the head alone or include the entire figure.

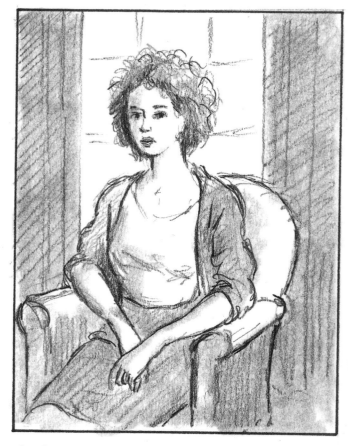
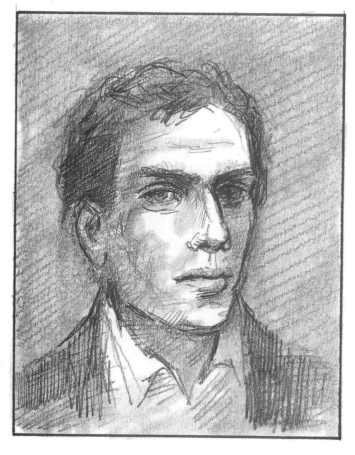

The first example shows the most conventional treatment of the sitter, occupying a central position in the picture, showing the top half of the figure with a simple background suggesting the room in which she is sitting. There are probably more portraits showing this proportion of the sitter than any other.

In the second picture, I have gone in close to the face of the sitter and the background is just a dark tone, against which the head is seen. The features are as large as possible without losing the whole head and all the attention is on the face.

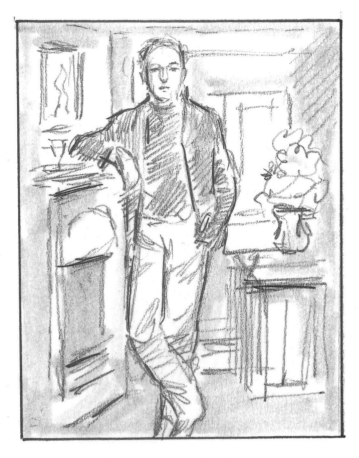

Below we see a figure, not quite complete, but taking on a more horizontal position. This could be done just as well in a landscape (horizontal) format, but can be most effective in the vertical. In this example, the space above the sitter becomes significant and often features some detail to balance the composition, like the picture shown.

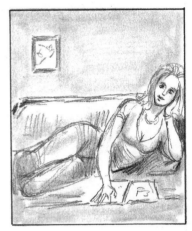

The picture above shows the other extreme, the full-figure portrait. Here, the figure is standing, with the surrounding room shown in some detail, although this does not always have to be the case; it could be an empty space or perhaps an outdoor scene. The full-length portrait is often a tour de force for the artist involved.

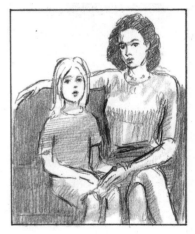

A double portrait – such as a parent and child – creates its own dynamic. Just decide how much of each figure you want to show and which to put in the centre of the composition. (See pages 40–41 for more on group portraits.)

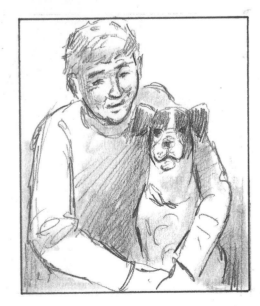

The final example is a portrait of the sitter and his dog. Putting pets into the portrait is always tricky, but the answer is to draw the animal first and then the owner. Once again, is the animal a mere adjunct or the centre piece?

Composition: Artists' Choices

Here we look at the various compositional choices made by artists to convey different effects and moods.

Celia Bennett's is the kind of portrait that shows only the head of the sitter, as large as possible in the frame, with a dead straight, full-face view. This style is what most people first think of when it comes to drawing a portrait, and it is a good way for you to start because it is a very basic version.

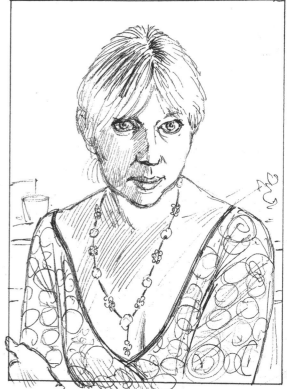

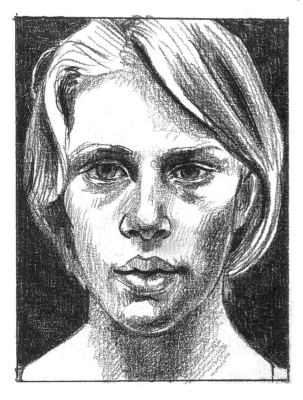

In this head and shoulders portrait after Keith Robinson, the sitter's head is slightly turned and lowered. The space around the head also gives a more formal effect to the portrait, but the whole look is very gentle and attractive.

In the next picture, after Lucie Cookson, you can see the upper torso and the arms of the sitter, and the head is turned to one side with the eyes directed away from the artist. This has the effect of making the portrait a little less head on, and allows the artist to give some sense of the sitter's body language. Note the rather interesting lighting as well.

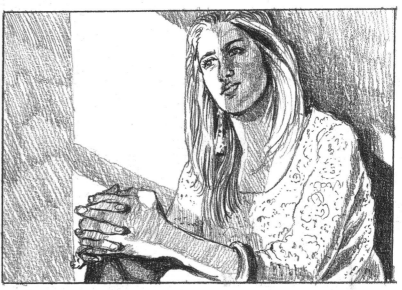

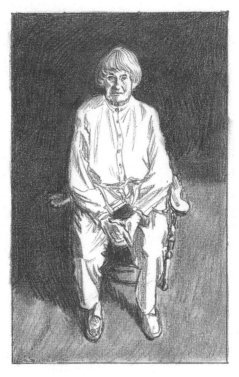

Now we see two full-length portraits, one sitting and one standing. They are both very uncompromising, being face on to the viewer, one against a dark background and one in a sort of bright floodlit style. Although Toby Wiggins' sitter on the left looks quite gentle and relaxed, because she is surrounded by space and the dark shadow of that space throws the figure forward, the effect is powerful and dramatic. Blaise Smith's standing figure on the right looks forceful, but her tough stance is made humorous by the terrier dog sitting alongside, also glaring at the artist.

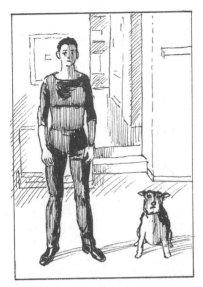

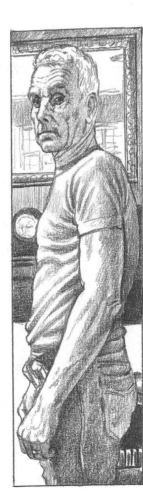

The next pair of portraits use the format of the frame to set off the figure in a different way that instantly attracts your attention. Vincent Brown's male figure is jammed sideways into a tight, narrow box of a frame that really makes you concentrate on the face and attitude of the sitter – a clever device to ensure that we look more closely.

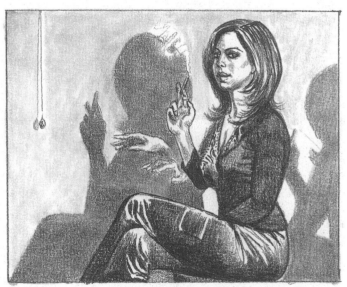

Sara Shamma's female figure is displayed like an exotic flower, her hand holding up a smoking cigarillo, with a jewelled pendant suspended in front of her. Her shadow cast on the background wall is complex and her hand is drawn several times as if the artist couldn't quite decide which was the best position. The whole effect is of this exquisite creature posing for our delight – an interesting statement by the artist of herself as a sort of odalisque.

Composition: Group Portraits

In these next portraits we look at compositions where there is more than one person portrayed. Drawing two or more people introduces a new dynamic into a portrait as you have to consider how the figures are to be placed within the frame and how they will interact together and with the viewer.

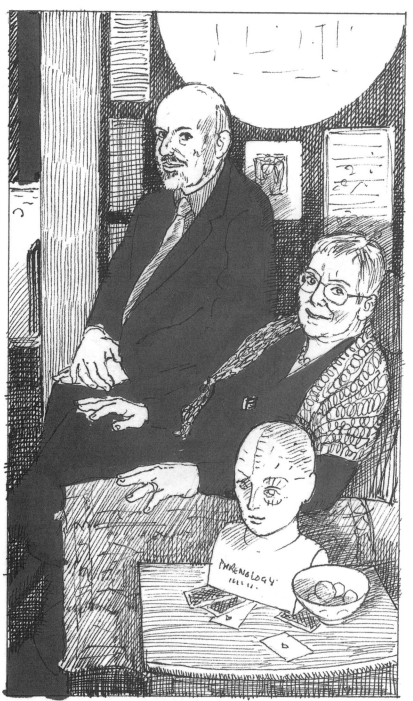

Professors Chris and Uta Frith, after artist Emma Wesley, is of a husband and wife sitting in their own study. The scene is full of what are probably connections with their own interests and academic work. They are closely placed together, but are looking at us sideways, as though we have just come into the room. It is both formal and friendly, which is quite a difficult thing to do, and shows the artist's powers.

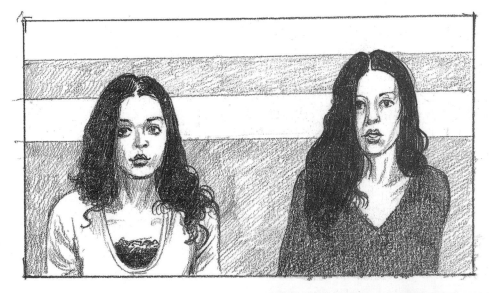

The example above, after Stephen Rogers, is of two young women, probably sisters, set up in a very formal side-by-side pose with an abstract background. They are both looking straight at the viewer, without any particular expression, as if they have been pinned down as objective recognition pictures, a bit like a double passport photograph – rather stark but also amusing.

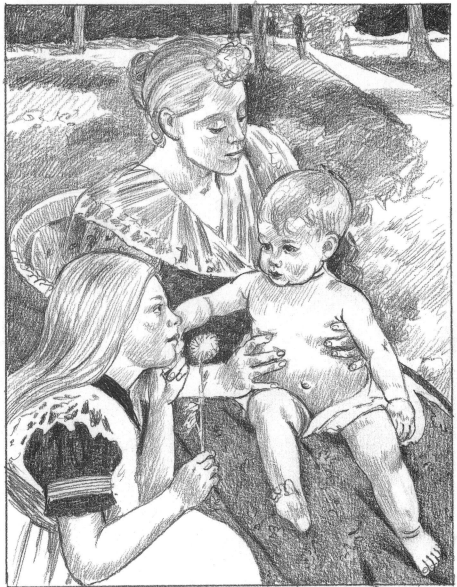

The third group portrait, after Mary Cassatt (1844–1926), is of a mother with daughter and baby, making a classic triangular composition, like a Renaissance Holy Family. The connections between them are more important than with the artist or viewer. They appear unaware of any onlooker.

A Portrait Project

In this final exercise you will learn a lot about your model's appearance by spending a whole session drawing and redrawing him or her from as many different angles as you think will be useful.

Sketches of the head

I chose as my sitter my eldest daughter, who has sat for me often, like all of my family. Not only that, she is an accomplished artist herself, so she knows the problems of drawing from life. This sympathy with your endeavours is useful, as models do get bored with sitting still for too long.

I worked my way round my sitter's head by drawing her first from the side or profile view, then from a more three-quarters view and finally full face. I now had a good idea as to the physiognomy of her face.

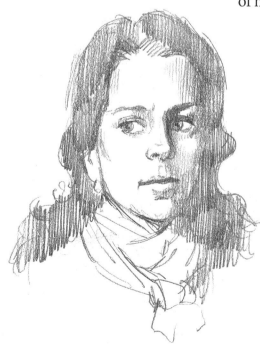

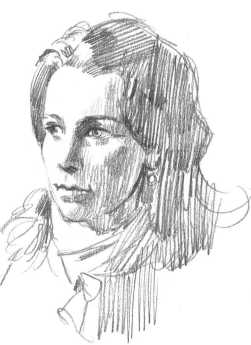

Next I took more account of the lighting, drawing her full-face and three-quarter face, both with strong light cast from the left.

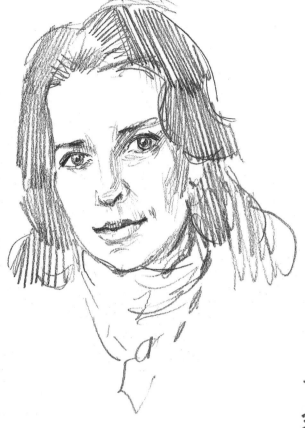

Then I tried very even lighting that reduced all the shadows to a minimum.

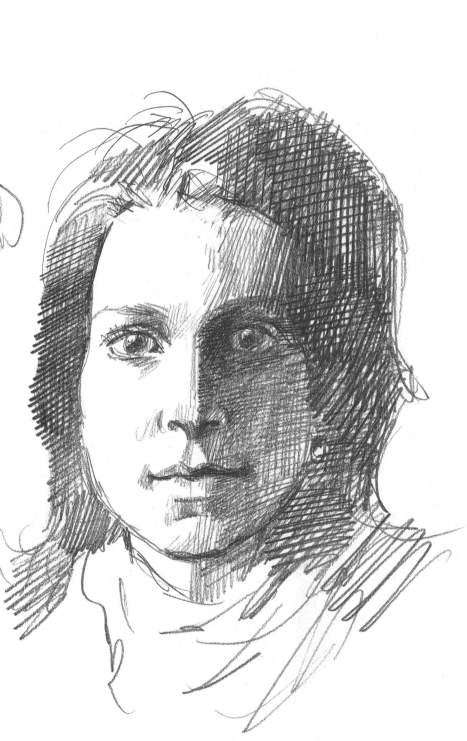

Here the light illuminates only one side of her face, making a strong shadow that divides the face in half.

Choose your composition

With my detailed drawings gathered together and my model refreshed and ready to sit for me again, I first had to choose the pose and then draw it up in as simple a way as possible but with all the information I needed to proceed to the finished portrait. I decided to place her on a large sofa, legs stretched out and hands in her lap, with her head slightly turned to look directly at me. The light was all derived from the large window to the left and so half of her face was in soft shadow.

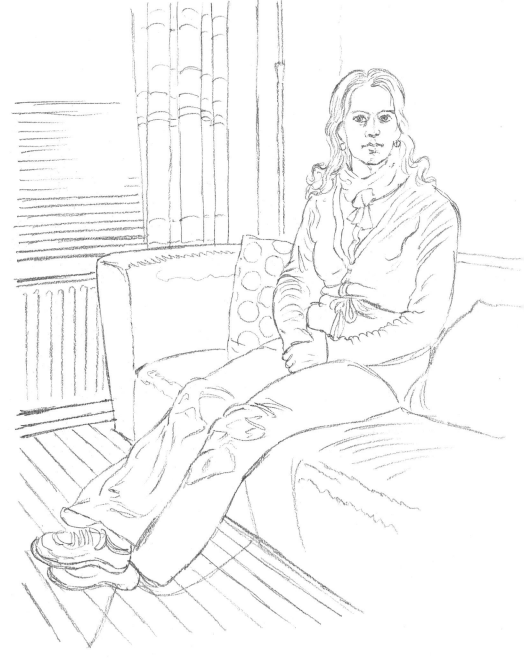

I then spent time drawing her in more detail, but without any shading, to create my cartoon. I tried to make it as correct as I could, but it didn't yet matter if the drawing was not quite as I wanted it because the purpose of the cartoon was to inform me as to what I needed to make the final piece of work. When artists in traditional ateliers were painting a large commission, they often drew up the whole thing full-size in an outline state from which to produce their final painting.

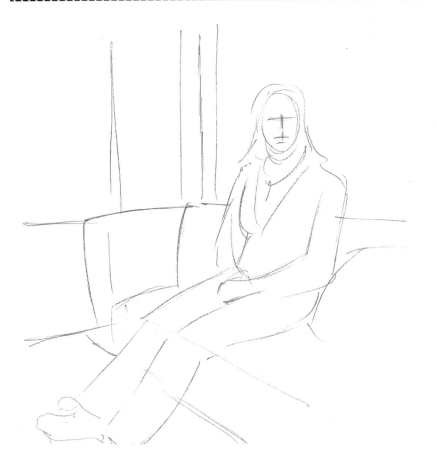

1. First I drew up a quick sketch that told me where everything would be placed. This almost exactly echoed the shape of my cartoon, which I had in front of me.

2. Then, still using my cartoon as a guide, I drew up a careful outline drawing of the whole figure and the background setting in some detail. This was the last stage at which I could introduce any changes if they were necessary.

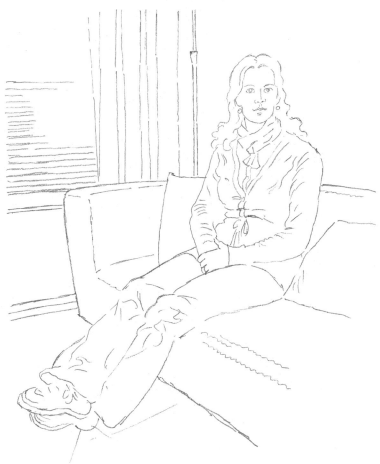

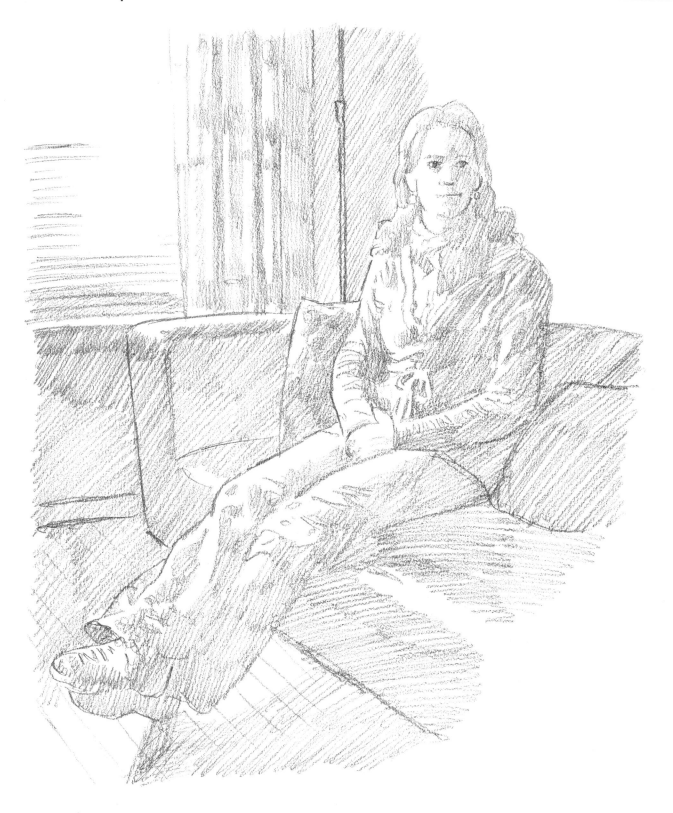

3. Next I began to put in the main area of tone evenly, using the lightest tone that would appear on the finished article.

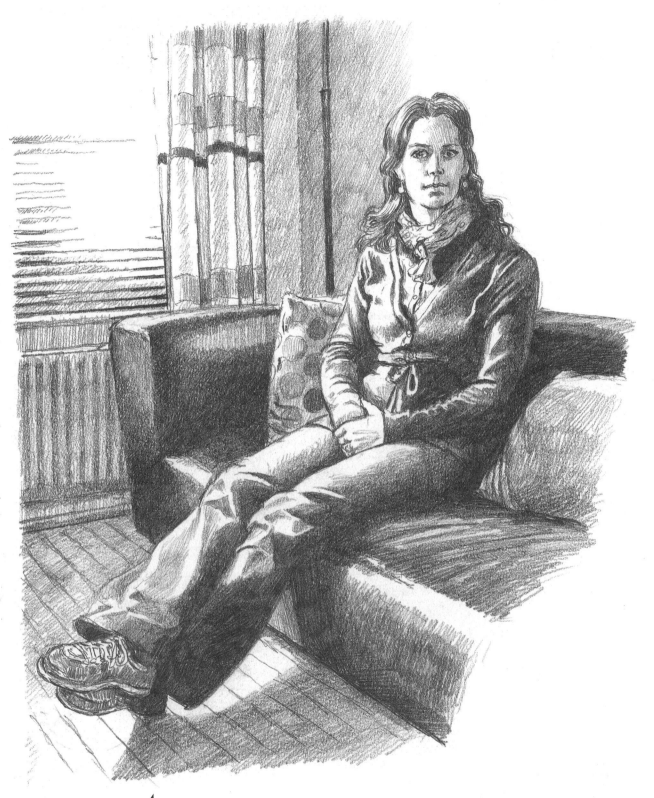

4. I could now build up all the different tones until I had produced a convincing three-dimensional portrait that looked like my sitter. This may have struck you as quite a long process, but if you take all this trouble to make your own portrait the chances are that not only will the sitter be pleased with the result, so will you.